Memories of Degas

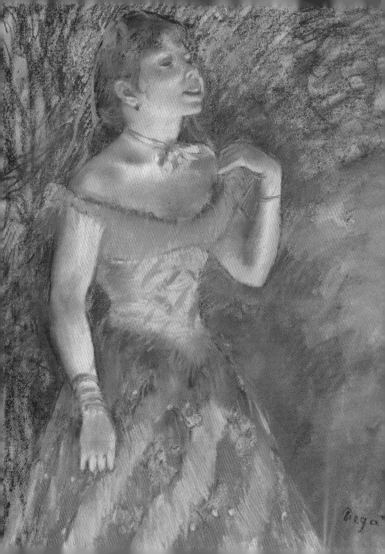

Memories of Degas

George Moore

Walter Sickert

introduced by
Anna Gruetzner Robins

The J. Paul Getty Museum, Los Angeles

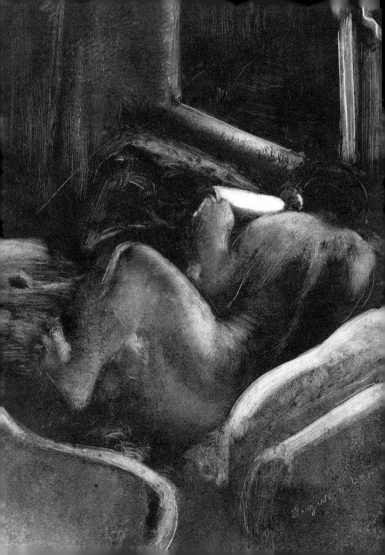

CONTENTS

Opposite: Woman Reading, 'Liseuse', c. 1885

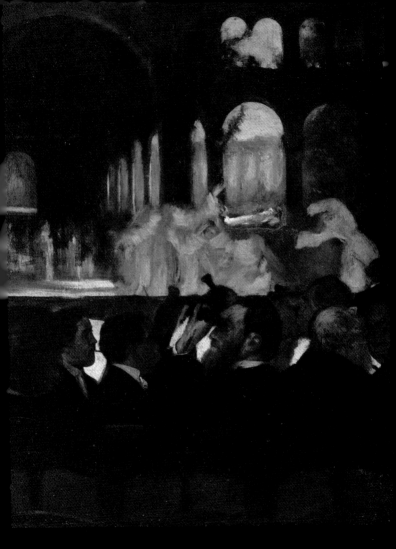

INTRODUCTION

ANNA GRUETZNER ROBINS

George Moore (1852-1933) and Walter Richard Sickert (1860-1942) were largely responsible for the received opinion amongst progressive artists and critics that Degas was 'perhaps one of the greatest artists the world has ever seen.' Moore, the Irish writer and critic, and Sickert, the Munich-born artist and critic, both of whom lived in London for the greater part of their adult lives, were privileged to know Degas well. They belonged to an interconnecting network of British and French writers and artists who met in London and Paris (and Dieppe), and their writings about Degas make a valuable contribution to our understanding of this complex but compelling artist. Degas's fame easily matched that of James McNeill Whistler, whom Moore describes as a lightweight and whose sartorial presence caused such ripples in the London art world, and Frederic, Lord Leighton, who created a palace to Æstheticism for work and pleasure in the house he built in London's Holland Park. With his background of money and privilege,

Opposite: The ballet from 'Robert le Diable', 1871

Degas could have easily competed with either artist for celebrity status in Britain, a country that craved news of its artists in the way it follows the lives of actors today. But as Moore and Sickert realized, making and collecting art came first for Degas, not the props of style and luxury that were necessary to many late nineteenth-century artists. Moore's descriptions of the 'perennial gloom and dust', the canvases 'pile[d] up in formidable barricades' and the 'decaying sculpture' in Degas's rue Fontaine St Georges studio, and Sickert's memories of the clutter in Degas's later studio, present a fascinating picture of the live-work spaces that he created in Montmartre. Degas does not fit the image of the bohemian artist. He did not womanise, live his life to excess or starve in a garret; but he was a modern artist who took risks. As Moore realised, Degas's cynical view of fame, his disdain for the pictures of successful but more conventional painters like Gérôme and Bastien-Lepage, Roll and Besnard, and his disregard for bourgeois necessities are symptomatic of this risk-taking and some of the identifying character-istics of the nineteenth-century modern artist.

When Moore published his 'Memories of Degas' in the *Burlington Magazine* he had not spoken to Degas for nearly thirty years, so it is hardly surprising that he decided to republish the important early article 'Degas: The Painter of Modern Life' of 1890. Moore

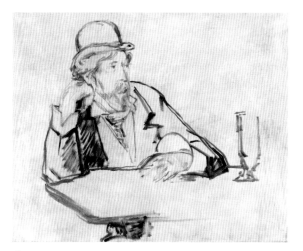

Édouard Manet, George Moore ('Au café'), 1878 or 1879

remembered meeting Degas around 1876 when he was a regular visitor to the Café de la Nouvelle Athènes, a haunt of the Impressionist painters and naturalist writers during the 1870s. Moore was privileged to gain first-hand contact with them, which he maintained after his return to London in 1879, making frequent trips to Paris during the following decade. His article on Degas is based on a recent visit to Degas's studio, possibly in 1888 when Moore found Degas reading his novel *Confessions*

of a Young Man, which was serialized in French that year and which contains a portrait of Degas.

When explaining the essential character of Degas's modernity, Moore sees Degas through the eyes of a novelist. Tellingly he mentions a recent drawing by Ingres that Degas recently acquired for his collection before explaining the two artists' similar interest in the expressive function of line in their drawing, as well as pointing out their significant differences. Because Degas represented dancers rather than goddesses from the Antique, he could be placed together with the best realist and naturalist French writers. The fragments of dancers that Degas depicted from unusual viewpoints and at odd angles were devised to give the illusion of movement. 'Dancers fly out of the picture, a single leg crosses the foreground' is one of Moore's pithy descriptions, but it matches the impressionistic perception of fleeting movement in Degas's dance pictures. As Moore said, Degas 'has done so many dancers' and 'so often repeated himself', but he had an uncanny way of identifying the distinctive characteristics of a picture like 'the great space of bare floor... balanced by the watering-pot' in *Dancers Practising at the Barre*, 1877 (Metropolitan Museum of Art, New York, reproduced p. 54), where that bare empty space is a soothing antidote to the tortuous poses of the dancers at the barre. Together with

this innovative approach of figure composition, Degas experimented with new techniques, including combinations of media, using pastel and distemper together for example. Moore was not at his best when describing these innovations, but by pointing out the 'new means' of Degas's 'novel and original manner', he was drawing attention to an essential aspect of the modernity of Degas's picture-making.

Moore was adept at recycling his writing on Impressionism, of using a review as the basis of a fictional narrative, of describing a picture in a novel, of expanding on his first viewing of it in his reminiscences, so that his writings create overlapping impressions of a single picture. Moore makes his readers believe that he is seeing the pastel nudes of 'three coarse women, middle-aged and deformed by toil' for the first time, but in fact, he had written about all three in a review of the 1886 Impressionist exhibition, and he also included a version of the review in a description of a visit to an Impressionist exhibition in *Confessions of a Young Man* where he telescopes several exhibitions into one.

Of all the Impressionist artists, Degas was most popular with British collectors, and he was the first to receive the institutional support of the Victoria and

Overleaf: Before the Race, c.1885

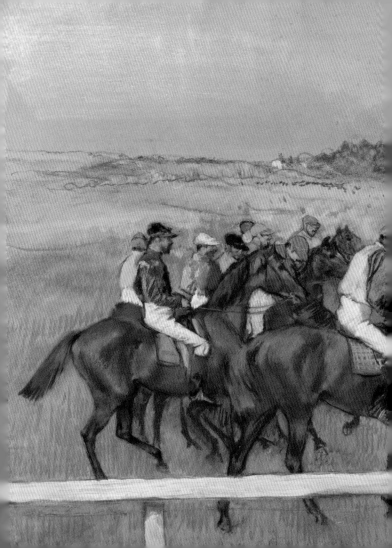

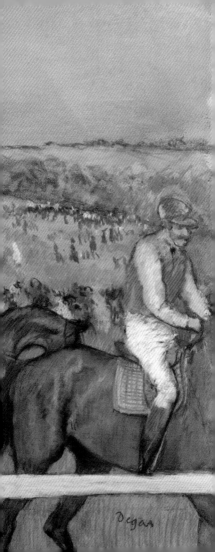

Albert Museum and the National Gallery. Moore's 1890 article was illustrated with Degas pictures from the collections of Constantine Ionides and Walter Sickert, who had used his wife's money to buy three of Degas's works, and his later reminiscences in the *Burlington Magazine* had illustrations from the collection of Sir William Eden, who was encouraged to collect by Moore and Sickert.

It is tempting to wonder whether Moore would have had a larger hand in introducing Degas to the British if he had not indiscreetly referred to the disastrous financial affairs of the Degas family in the 1890 article, as a result of which a furious Degas never spoke to him again. His 'Memories of Degas' were very old memories indeed. It was different for Sickert, who was twenty-three when he first met Degas in 1883, and around fifty-three, the age that Degas was when they first met, when he saw Degas for the last time just before the Great War. His tribute, written shortly after Degas's death, is a time capsule of a thirty-year friendship played out during a memorable summer in Dieppe in 1885, in the exhibitions they saw together in Paris, and in the various studios that Degas inhabited until he finally settled at 37 rue Victor Massé in 1890, where he took over two more floors in 1897 and lived until 1912. Passing its demolished walls, Sickert in a poignant moment recalls that Degas's live-work space

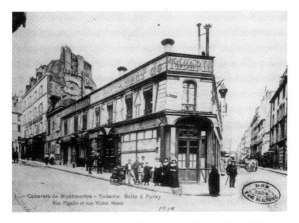

Rue Victor Massé, c. 1904. Degas' block is on the right, opposite the Bal Tabarin on rue Pigalle

– with the first floor for living, the middle one for his large collection, and the third as his studio – had been the 'lighthouse of my existence.'

When Sickert first knocked on his door in 1883 Degas was a noted recluse, but Sickert brushed aside his excuse of sickness, always the explanation of a depressive, and persuaded Degas to show him all the work that he could. Sickert's reminiscences are filled with memories of his viewings of Degas's work and collection, such as his 1883 sighting of the wax sculptures Degas kept under glass

(on Sickert's last visit Degas would take one of these stat-
uettes and turn it in front of a candle to show the chang-
ing movement of its form in shadow) and the recent
pastel bathers that Degas showed him and his first wife
Ellen Cobden when they visited him in Paris in 1885.
Degas told them that 'Je veux regarder par le trou de la
serrure' (I want to look through a keyhole) as a way of
explaining the close-up, cut-off viewpoint that charac-
terise his representations of these female bathers who are
seemingly unaware of the viewer. Some of these pastels
were the cause of critical scandal when Degas exhibited
them at the last Impressionist exhibition the following
year. When he asked Sickert what would happen if he
sent them to the Royal Academy ('Qu'est qu'ils feraient
à l'Académie Royale si je leur envoyais ça?'), Sickert told
him that he would be shown the door. It still seems
remarkable that Degas's pastels might have graced the
walls of the Royal Academy in 1886.

Degas made several trips to England, including one
wto Brighton to visit Henry Hill, an important early
collector who acquired five Degas ballet pictures in
the 1870s, one of them *The Rehearsal of the Ballet on
Stage*, c. 1873-74 (The Metropolitan Museum of Art, re-
produced pp. 18-19), which Sickert later bought for his
own collection. (At one point, Hill apparently thought
of leaving them to the Brighton Art Gallery. What a

Degas and Sickert in Dieppe, 1885

treasure trove that would have been!) Degas's comments about English artists speak of a keen interest in what took place on the other side of the Channel. Degas might have mocked the habits of the Pre-Raphaelite John Everett Millais, who dressed as an English gentleman, in stark contrast to Degas's shabby bohemian style, but this did not stop Degas from admiring his pictures, including Millais's *Eve of St Agnes*, 1862-63 (Royal Collection), at the 1867 Paris Universal Exhibition. When he visited another Universal Exhibition in Sickert's company in 1889,

Overleaf: The Rehearsal of the Ballet on Stage, c. 1873-74

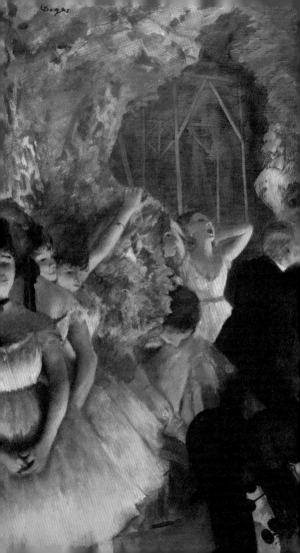

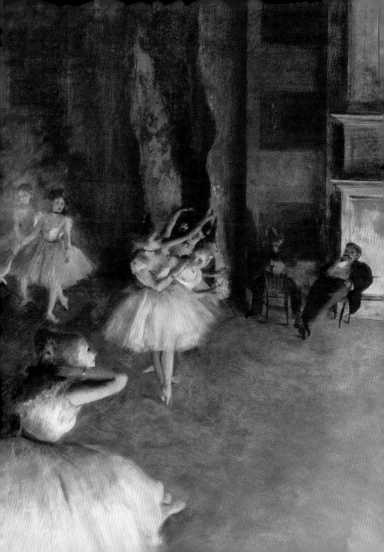

English pictures like the little-known James Charles's *Christening Sunday* (Manchester City Art Gallery) or William Orchardson's *Master Baby*, 1886 (National Gallery of Scotland), with suppressed or unresolved narrative, impressed him, possibly because many of his figure compositions, including the early ballet pictures, resonate with the same ambiguity of meaning.

All of Degas's encounters with Sickert took place in France, and Sickert's tribute to him is peppered with more than its usual share of French, with a bit of German and Italian thrown in to show off his cosmopolitanism. Sickert spoke French fluently, which made it easy for him to share what he called Degas's 'rollicking and somewhat bear-like sense of fun' when Degas fired off one of his customary bon-mots. Who could forget his comment to Sickert about the *Waterlilies* by his Impressionist colleague Monet: 'I don't feel the need to swoon in front of a pool' (Je n'éprouve pas le besoin de perdre connaissance devant un étang)? Or his remark when Whistler was expected in Dieppe where Degas and Sickert were staying in 1885: 'Playing the butterfly must be very exhausting. I prefer the part of the old ox, what?' ('Le rôle de papillon doit être bien fatiguant, allez! J'aime mieux, moi, être le vieux boeuf, quoi?'). There was a tug of war over Sickert that summer when Whistler's favourite pupil and follower fell under Degas's spell, and was rewarded accordingly

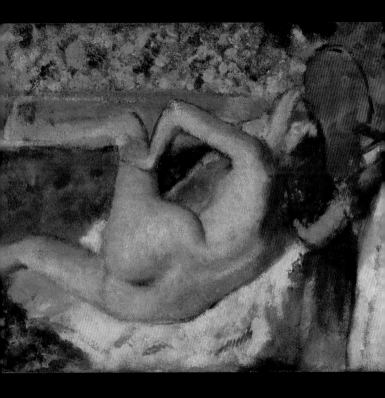

After the Bath, c. 1895

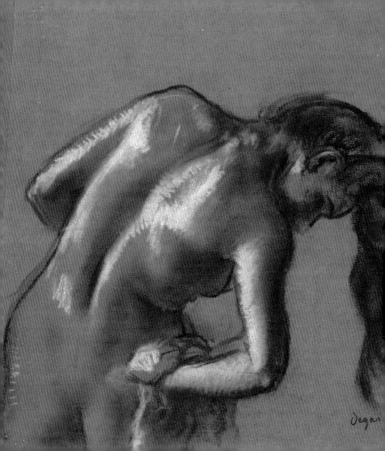

when Degas included him in an extraordinary group pastel portrait *Six Friends at Dieppe*, 1885 (Museum of Art, Rhode Island School of Art, reproduced p. 84). The pastel was drawn from life in the Dieppe studio of Jacques-Emile Blanche and the occasion was the first of many opportunities for Sickert to observe Degas at work, and to see what effort went into giving the impression that the complex grouping of figures had happened by accident. As Degas told Sickert: 'You create the effect of truth by means of falsehood.' (On donne l'idée du vrai avec le faux.') The 'false means' involved piecing, or what Sickert called joining, 'together firmly an immense quantity of first rate material', meaning the figure studies that Degas drew and redrew with such extraordinary aplomb before arranging and rearranging them on paper and canvas in compositional arrangements that have a striking casual immediacy about them.

That Moore and Sickert wrote such interesting and interconnecting first-hand accounts of Degas, that continue to be worthwhile introductions to his art, is a lasting testimony to their friendship with him.

Opposite: Bather Drying Herself, c. 1892

GEORGE MOORE

Memories of Degas

January 1918

*Originally published in November 1890 as
'Degas: The Painter of Modern Life'*

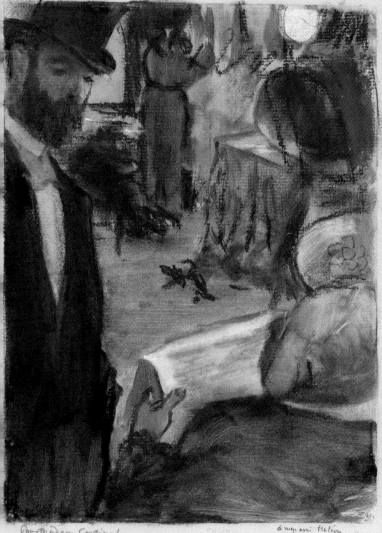

Pour Madam Cardinal

à mon ami Halévy
Degas

In his lifetime legends began to gather about him, and the legend that has attained the greatest currency is that Degas was an old curmudgeon who hated his kind and kept his studio door locked. As early as '76 – it was about that time I made his acquaintance in the Nouvelle Athènes – I heard him described as harsh and intractable, but I could not see that he was either, and wondered why people should speak of him with bated breath, as if in terror, for indeed he seemed the type and epitome of a French gentleman, as I conceived it to be. He was courteous to all who knew him, entered into conversation with all who asked to be introduced to him, and invited those who seemed interested in his painting to his studio. Why then the legend? Degas put himself forward as an old curmudgeon, and as it is always easier to believe than to observe, he became one in popular imagination; and by degrees this very courteous and kind gentleman, loving his kindred and finding happiness in society, became moulded and fashioned by the words he had uttered casually, without foreseeing that sooner or later he would have to live up to them. He said that he would never speak to a man who wrote about him in the newspapers.

Opposite: Ludovic Halévy finds Madame Cardinal in the wings, 1876-77

He described journalists as pests. 'The artist,' he said, 'must live apart, and his private life remain unknown.' The power of speech is greater within than without and in the end every man falls a victim to his words.

Said I to him once: 'How are your works to become known?' He answered, 'I've never heard of anyone buying a picture because it was spoken about in a newspaper: a man buys a picture because he likes it or because somebody told him to buy it.' It may be that I have quoted these words of Degas before; they may be in the article to be laid before the readers of *The Burlington*, but if they are I have repeated myself, a licence that must be allowed to everybody on occasions.

And now I bring to my telling a fact that is testification of the truth of what I have said regarding Degas's natural character and how his artificial character came into being. I forgot Degas's warning that he would never speak to anyone who wrote about him, and went to Paris, forgetful that Degas and his opinions were in *Confessions of a Young Man*. I called one morning at his studio in the rue Fontaine. He pulled the string at the foot of the spiral staircase. I went up and found Degas reading amid his lithographic presses my book in a French translation. And for a moment I stood like one frozen; but Degas was

amiable – highly pleased expresses his mood – with all I had said of him – so pleased, indeed, that he took me out to breakfast and entertained me, as he never failed to do, with wit and wisdom till late in the afternoon. He spoke of my book to the crowd his personality collected about him; he had passages off by heart; and encouraged by his enjoyment I began to meditate an article on Degas, untroubled by any fear of an interruption in our intimacy. His dislike of notoriety is purely an imaginary one, I said to myself. So it was, and the article might have proved as acceptable to Degas as the book had done if somebody had not unfortunately told me that Degas's brother had lost a great deal of money in Mexico, and that Degas had proved himself a great brother on that occasion, saving his brother from bankruptcy.

As the article happened to be one of my best articles (it could not be else since it was written out of a very complete knowledge of the subject and with enthusiasm and love), it attracted attention in France, and Degas found himself in a dilemma. He had given out to the world that he would never speak to anybody who related his private life in an article. He either had to allow that he was not a man of his word or he had to break with a friend, one who I have reason to believe was a dear friend. Mine was a flagrant instance.

I counted on the help of Ludovic Halévy, but despite all Halévy could do and Madame Halévy to bring us together he persisted in his determination not to see me, till he fell under the power of remembrance, and sent me word that he would be glad to see me when I came to Paris again. But it is difficult to renew a friendship that was as close as ours after several years; I did not feel that it could be renewed, and never saw Degas again.

The last news I heard of him came through Monsieur Lafond, the curator of the National Museum, at Pau. Monsieur Lafond wrote to me asking me in which book he would find my article on Degas, and I sent him *Impressions and Opinions*, and a correspondence followed the sending of this book, and a phrase of this kind occurs in his last letter to me: 'Degas lives alone almost blind, seeing nobody, without any kind of occupation.' The letter fell from my hands and I fell to thinking of the old man of genius hearing of his pictures selling for thousands and unable to see them, sitting, thinking, weary of his life.

Into this solitude a certain French nobleman, the Playboy of Paris, the inspiration of Huysmans' Des Esseintes, the hero of *À Rebours*, succeeded at last in clambering through an unguarded loophole and reaching Degas. 'Why, Monsieur Degas,' he asked,

'do you remain always at Monmartre; why not let me take you to the Faubourg St. Germain?' The answer he got was: 'Monsieur le comte de – , leave me upon my dunghill' – a quip that seems to me as worthy of quotation as any in the huge dish of Degas's table talk that Mr. Walter Sickert laid before the readers of *The Burlington Magazine* in a recent number. However this may be, it will help to make clear a point that Mr. Walter Sickert had in mind when he was compiling his list of quips. He seems to have felt that any criticism written at the present time about Degas's work could not be else than a languid repetition of things that have been said and re-said for the last ten or a dozen years. Since we must write about Degas, Mr. Walter Sickert thinks that our memories are more valuable than our thoughts. We are at agreement in this, but an article written twenty years ago with enthusiasm and love, when Degas was a nightly speaker in the Nouvelle Athènes, may be acceptable; it will certainly be more palatable than anything I could write now. And that is why I pressed it upon the editor of *The Burlington*, saying: 'why print a new article that must be bad instead of a good one that is unknown to the large majority of your readers? The few that have read it probably preserve a pleasant memory of it, and will be glad to read it again.'

DEGAS: THE PAINTER OF MODERN LIFE
1890

One evening, after a large dinner party, given in honour of the publication of *L'Œuvre*, when most of the guests had gone, and the company consisted of *les intimes de la maison*, a discussion arose as to whether Claude Lantier was or was not a man of talent. Madame Charpentier, by dint of much provocative asseveration that he was undistinguished by hardly any shred of the talent which made Manet a painter for painters, forced Émile Zola to take up the cudgels and defend his hero. Seeing that all were siding with Madame Charpentier, Zola plunged like a bull into the thick of the fray, and did not hesitate to affirm that he had gifted Claude Lantier with infinitely higher qualities than those which nature had bestowed upon Édouard Manet. This statement was received in mute anger by those present, all of whom had been personal friends and warm admirers of Manet's genius, and cared little to hear any word of disparagement spoken of their dead friend. It must be observed that M. Zola intended no disparagement of M. Manet, but he was concerned to defend the theory of his book – namely,

Opposite: Ballerina posing for a photograph, c. 1877-79

that no painter working in the modern movement
had achieved a result proportionate to that which had
been achieved by at least three or four writers working
in the same movement, inspired by the same ideas,
animated by the same æstheticism. And, in reply to
one who was anxiously urging Degas's claim to the
highest consideration, he said, 'I cannot accept a man
who shuts himself up all his life to draw a ballet-girl as
ranking co-equal in dignity and power with Flaubert,
Daudet, and Goncourt.'

Some four, or perhaps five, years after, one morning
in May, a friend tried the door of Degas's studio. It is
always strictly fastened, and when shaken vigorously
a voice calls from some loophole; if the visitor be an
intimate friend, a string is pulled and he is allowed to
stumble his way up the cork-screw staircase into the
studio. There are neither Turkey carpets nor Japanese
screens, nor indeed any of those signs whereby we
know the dwelling of the modern artist. Only at the
further end, where the artist works, is there daylight.
In perennial gloom and dust the vast canvases of his
youth are piled up in formidable barricades. Great
wheels belonging to lithographic presses – lithogra-
phy was for a time one of Degas's avocations – suggest
a printing-office. There is much decaying sculpture –
dancing-girls modelled in red wax, some dressed in

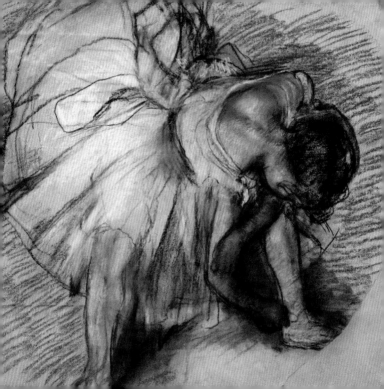

muslin skirts, strange dolls – dolls if you will, but dolls modelled by a man of genius.

On that day in May Degas was especially anxious for breakfast, and he only permitted his visitor to glance at the work in progress, and hurried him away to meal with him – but not in the café; Degas has lately relinquished his café, and breakfasts at home, in an apartment in the rue Pigalle, overlooking a court-yard full of flowering chestnut-trees.

As they entered the apartment the eye of the visitor was caught by a faint drawing in red chalk, placed upon a sideboard; he went straight to it. Degas said, 'Ah! Look at it, I bought it only a few days ago; it is a drawing of a female hand by Ingres; look at those finger-nails, see how they are indicated. That's my idea of genius, a man who finds a hand so lovely, so wonderful, so difficult to render, that he will shut himself up all his life, content to do nothing else but indicate finger-nails.'

The collocation of these remarks by Zola and Degas – two men of genius, working in the same age, floating in the same stream of tendency, although in diverging currents – cannot fail to move those who are interested in the problem of artistic life. Perhaps never before did chance allow a mutual friend to snatch out of the oblivion of conversation two

such complete expressions of artistic sensibility; the document is sufficient, and from it a novelist should be able to construct two living souls. Two types of mind are there in essence; two poles of art are brought into the clearest apprehension, and the insolvable problem, whether it be better to strive for almost everything, or for almost nothing, stares the reader in the face; we see Zola attempting to grasp the universe, and Degas following the vein of gold, following it unerringly, preserving it scrupulously from running into slate. The whole of Degas's life is in the phrase spoken while showing his visitor the drawing in red chalk by Ingres. For no man's practice ever accorded more nearly with his theory than Degas. He has shut himself up all his life to draw again and again, in a hundred different combinations, only slightly varied, those few aspects of life which his nature led him to consider artistically, and for which his genius alone holds the artistic formulæ.

Maupassant says in his preface to Flaubert's letters to Geo. Sand: — 'Nearly always an artist hides a secret ambition, foreign to art. Often it is glory that we follow, the radiating glory that places us, living, in apotheosis, frenzies minds, forces hands to applaud, and captures women's hearts… Others follow money, whether for itself, or the satisfaction that it

gives — luxuries of life and the delicacies of the table. Gustave Flaubert loved letters in so absolute a fashion that, in his soul, filled with this love, no other ambition could find a place.'

With the single substitution of the word 'painting' for 'letters', this might be written with perfect truth of Degas. To those who want to write about him he says, 'Leave me alone; you didn't come here to count how many shirts I have in my wardrobe?' 'No, but your art. I want to write about it.' 'My art, what do you want to say about it? Do you think you can explain the merits of a picture to those who do not see them? Dites? ... I can find the best and clearest words to explain my meaning, and I have spoken to the most intelligent people about art, and they have not understood – to B– , for instance; but among people who understand words are not necessary, you say – humph, he, ha, and everything has been said. My opinion has always been the same. I think that literature has only done harm to art. You puff out the artist with vanity, you inculcate the taste for notoriety, and that is all; you do not advance public taste by one jot ... Notwithstanding all your scribbling it never was in a worse state than it is at present... Dites? You do not even help us to sell our

Opposite: Dancer, c. 1880

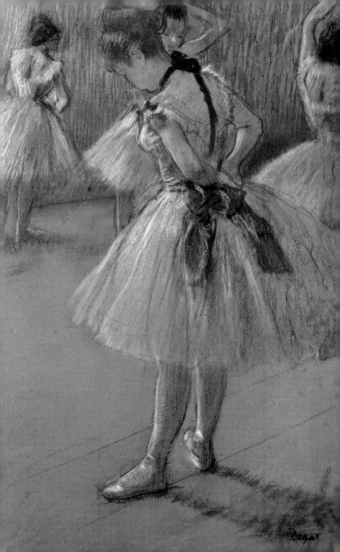

pictures. A man buys a picture not because he read an article in a newspaper, but because a friend, who he thinks knows something about pictures, told him it would be worth twice as much ten years hence as it is worth to-day… Dites?'

In these days, when people live with the view to reading their names in the paper, such austerity must appear to many like affectation; let such people undeceive themselves. Never was man more sincere; when Degas speaks thus he speaks the very essence of his being. But perhaps even more difficult than the acceptation of this fact will be found the association of such sentiments with a sweet genial nature, untouched with misanthropy or personal cynicism. Degas is only really cynical in his art, and although irony is an essential part of him, it finds expression in a kindly consciousness of the little weaknesses of human nature when directed against those he loves. For instance, when he is in company with any one who knew Manet, his confrère and compeer in realistic pictorial art, and the friend of his life, he loves to allude to those little childishnesses of disposition which make Manet's memory a well-beloved, even a sacred thing.

'Do you remember,' Degas said, as he hurried his friend along the rue Pigalle, 'how he used to turn on me when I wouldn't send my pictures to the Salon?

He would say, "You, Degas, you are above the level of the sea, but for my part, if I get into an omnibus and some one doesn't say: 'M. Manet, how are you, where are you going?' I am disappointed, for I know then that I am not famous.'" Manet's vanity, which a strange boyishness of disposition rendered attractive and engaging, is clearly one of Degas's happiest memories, but all the meanness of *la vie de parade*, so persistently sought by Mr. Whistler, is bitterly displeasing to him. Speaking to Mr. Whistler, he said, 'My dear friend, you conduct yourself in life just as if you had no talent at all.' Again speaking of the same person, and at the time when he was having numerous photographs taken, Degas said, 'You cannot talk to him; he throws his cloak around him – and goes off to the photographer.'

A dozen, a hundred other instances, all more or less illustrative of the trait so dominant and decisive in Degas, which leads him to despise all that vain clamour which many artists are apt to consider essential, and without which they are inclined to deem themselves unjustly treated or misunderstood, might be cited. One more will, however, suffice. Speaking to a young man hungering for drawing-room successes, he says, and with that jog of the elbow so familiar in him, 'Jeune M—, dans mon temps

on n'arrivait pas, dites?'* And what softens this austerity, and not only makes it bearable but most winsome and engaging, is the conviction which his manner instils of the very real truth, of the unimpeachableness of the wisdom which he expresses by the general conduct of his life and by phrases pregnant with meaning. Nor is it ever the black wisdom of the pessimist which says there is no worth in anything but death, but the deeper wisdom, born it is true of pessimism, but tempered in the needs of life, which says: 'Expend not your strength in vain struggling in the illusive world, which tempts you out of yourself; success and failure lie within and not without you; know yourself, and seek to bring yourself into harmony with the Will from which you cannot escape, but with which you may bring yourself into obedience, and so obtain peace.'

In accordance with this philosophy, Degas thinks as little of Turkey carpets and Japanese screens as of newspaper applause, and is unconcerned to paint his walls lemon yellow; he puts his æstheticism upon his canvases, and leaves time to tint the fading whitewash with golden tints. They are naked of ornament, except a few *chefs-d'œuvre* which he will not part with,

* 'Young M –, in my day one didn't arrive, what?'

a few portraits, a few pictures painted in his youth. Looking at *Semiramis Building the Walls of Babylon*, Manet used to say, 'Why don't you exhibit it, *cela fera de la variété dans votre œuvre*?'* There is a picture of some Spartan youths wrestling which Gérôme once ventured to criticise; Degas answered, 'Je suppose que ce n'est pas assez turc pour vous, Gérôme?'† Not in his dress nor in his manner will you note anything glaringly distinctive, but for those who know him the suit of pepper-and-salt and the blue necktie tied round a loose collar are full of *him*. For those who know him the round shoulders, the rolling gait, and the bright, hearty, essentially manly voice are brimmed with individuality; but the casual visitor of the Café de la Rochefoucauld would have to be more than usually endowed with the critical sense to discern that Degas was not an ordinary man. To pass through the world unobserved by those who cannot understand him – that is, by the crowd – and to create all the while an art so astonishingly new and so personal that it will defy imitator, competitor, or rival, seems to be his ambition, if so gross a term can be used

* 'That will bring some variety into your work?' † 'I suppose that that isn't Turkish enough for you, Gérôme?'

Overleaf: Young Spartans exercising, c. 1860

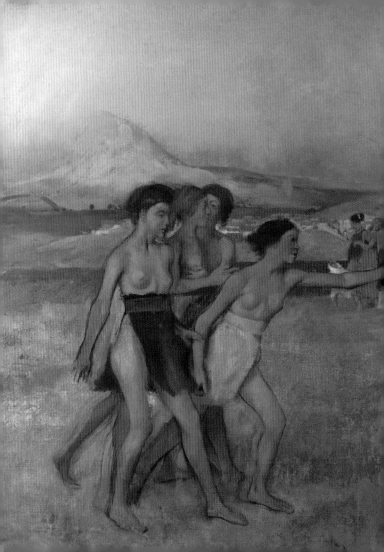

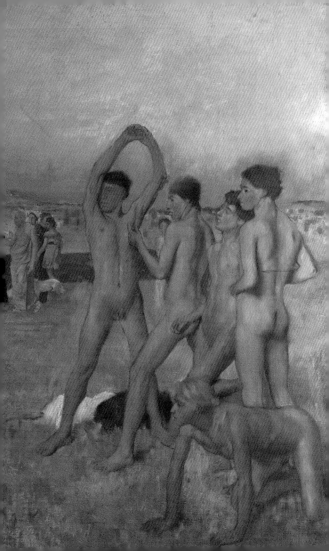

without falsifying the conception of his character. For Degas seems without desire of present or future notoriety. If he could create his future as he has created his present, his future would be found to be no more than a continuation of his present. As he has in life resolutely separated himself from all possibility of praise, except from those who understand him, he would probably, if he could, defend himself against all those noisy and posthumous honours which came to the share of J. F. Millet; and there can be but little doubt that he desires not at all to be sold by picture-dealers for fabulous prices, but rather to have a quiet nook in a public gallery where the few would come to study. However this may be, it is certain that to-day his one wish is to escape the attention of the crowd. He often says his only desire is to have eyesight to work ten hours a day. But he neither condemns nor condones the tastes and the occupations of others; he is merely satisfied that, so far as he is concerned, all the world has for giving is untroubled leisure to pursue the art he has so laboriously invented. For this end he has for many years consistently refused to exhibit in the Salon; now he declines altogether to show his pictures publicly.

In old times, after a long day spent in his studio, he would come to the Nouvelle Athènes late in the

evening, about ten o'clock. There he was sure of meeting Manet, Pissaro and Duranty, and with books and cigarettes the time passed in agreeable æstheticisms. Pissaro dreamy and vague; Manet loud, declamatory, and eager for medals and decorations; Degas sharp, deep, more profound, scornfully sarcastic; Duranty clear-headed, dry, full of repressed disappointment. But about the time of Manet's death the centre of art shifted from the Nouvelle Athènes to the Café de la Rochefoucauld. Degas followed it. He was seen there every evening, and every morning he breakfasted there – every year looming up greater and more brilliant in the admiration of the young men. Latterly Degas has abandoned café life. He dines with Ludovic Halévy and a few friends whom he has known all his life; he goes to the opera or the circus to draw and find new motives for pictures. Speaking to a landscape-painter at the Cirque Fernando, he said, 'A vous il faut la vie naturelle, à moi la vie factice.'*

From the quotations scattered in the foregoing paragraphs the reader has probably gathered that Degas is not deficient in verbal wit. Mr. Whistler has in this line some reputations, but in sarcasm he is to Degas what Theodore Hook was to Swift, and

* 'For you, it's nature you need; for me, I need artifice.'

when Degas is present Mr. Whistler's conversation is distinguished by 'brilliant flashes of silence'. Speaking of him one day, Degas said, 'Oui, il est venu me voir.' 'Well, what did he say to you?' 'Rien, il a fait quelques coups de mèche, voilà tout.'* One day, in the Nouvelle Athènes, a young man spoke to him of how well Manet knew how to take criticism. 'Oui, oui, Manet est très Parisien, il comprend la plaisanterie.'('Yes, Manet is a true Parisian, he knows how to take a joke.') Speaking of Besnard's plagiarisms, 'Oui, oui, il *vole* avec nos propres ailes.'† Speaking of Bastien-Lepage's picture, *La récolte des pommes de terres*, 'C'est le Bouguereau du mouvement moderne';‡ and of Roll's picture of *Work*, 'Il y a cinquante figures, mais je ne vois pas la foule; on fait une foule avec cinq et non pas avec cinquante.' ('There are fifty figures, but I see no crowd; you can make a crowd with five figures, not with fifty.') At a dinner at Bougival he said, looking at some large trees massed in shadow, 'How beautiful they would be if Corot had painted them!' And speaking of Besnard's effort to attain lightness of treatment, he said, 'C'est un homme qui veut danser

* 'Yes, he came to see me.'; 'Nothing, he tossed his hair about a couple of times, that's all.' † 'Yes, he is flying/stealing – with our wings.' ‡ 'He is the Bouguereau of the modern movement.'

avec des semelles de plomb.' ('He is a man who tries to dance with leaden soles.')

Of Degas's family history it is difficult to obtain any information. Degas is the last person of whom inquiry could be made. He would at once smell an article, and he nips such projects as a terrier nips rats. The unfortunate interlocutor would meet with this answer, 'I didn't know that you were a reporter in disguise; if I had, I shouldn't have received you.' It is rumoured, however, that he is a man of some private fortune, and a story is in circulation that he sacrificed the greater part of his income to save his brother, who had lost everything by imprudent speculation in American securities. But what concerns us is his artistic not his family history.

Degas was a pupil of Ingres, and any mention of this always pleases him, for he looks upon Ingres as the first star in the firmament of French art. And, indeed, Degas is the only one who ever reflected, even dimly, anything of the genius of the great master. The likeness to Ingres which some affect to see in Flandrin's work is entirely superficial, but in the *Semiramis Building the Walls of Babylon* and in the *Spartan Youths* there is a strange fair likeness to the master, mixed with another beauty, still latent, but ready for afflorescence, even as the beauty of the mother floats evanescent

upon the face of the daughter hardly pubescent yet. But if Degas took from Ingres that method of drawing which may be defined as drawing by the character in contradistinction to that of drawing by the masses, he applied the method differently and developed it in a different direction. Degas bears the same relation to Ingres as Bret Harte does to Dickens. In Bret Harte and in Dickens the method is obviously the same when you go to its root, but the subject-matter is so different that the method is in all outward characteristics transformed, and no complaint of want of originality of treatment is for a moment tenable. So it is with Degas; at the root his drawing is as classical as Ingres's, but by changing the subject-matter from antiquity to the boards of the opera-house, and taking curiosity for leading characteristic, he has created an art cognate and co-equal with Goncourt's, rising sometimes to the height of a page by Balzac. With marvellous perception he follows every curve and characteristic irregularity, writing the very soul of his model upon his canvas. He will paint portraits only of those whom he knows intimately, for it is part of his method only to paint his sitter in that environment which is habitual to her or him. With stagey curtains, balustrades,

Opposite: Mademoiselle Bécat at the Café des Ambassadeurs, 1877-85

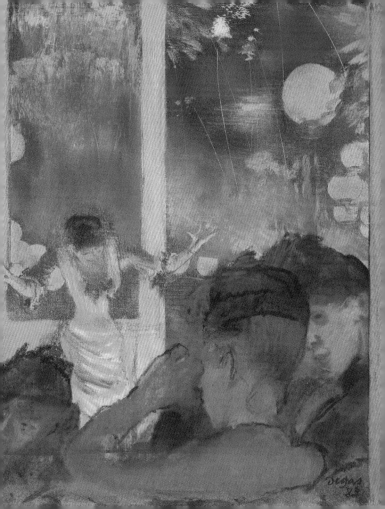

and conventional poses, he will have nothing to do. He will watch the sitter until he learns all her or his tricks of expression and movement, and then will reproduce all of them and with such exactitude and sympathetic insight that the very inner life of the man is laid bare. Mr. Whistler, whose short-sightedness allows him to see none of these beauties in nature, has declared that all such excellencies are literary and not pictorial, and the fact that he was born in Baltimore has led him to contradict all that the natural sciences have said on racial tendencies and hereditary faculties. But there are some who still believe that the *Ten o'Clock* has not altogether overthrown science and history, and covered with ridicule all art that does not limit itself to a harmony in a couple of tints. And that Degas may render more fervidly all the characteristics that race, heredity and mode of life have endowed his sitter with, he makes numerous drawings and paints from them; but he never paints direct from life. And as he sought new subject-matter, he sought for new means by which he might reproduce his subject in an original and novel manner. At one time he renounced oil painting entirely, and would only work in pastel or distemper. Then, again, it was water-colour painting, and sometimes in the same picture he would abandon one medium for another. There are examples

extant of pictures begun in water-colour, continued in gouache, and afterwards completed in oils; and if the picture be examined carefully it will be found that the finishing hand has been given with pen and ink. Degas has worked upon his lithographs, introducing a number of new figures into the picture by means of pastel. He has done beautiful sculpture, but not content with taking a ballet-girl for subject, has declined to model the skirt, and had one made by the nearest milliner. In all dangerous ways and perilous straits he has sought to shipwreck his genius; but genius knows no shipwreck, and triumphs in spite of obstacles. Not even Wagner has tested more thoroughly than Degas the invincibility of genius.

If led to speak on the marvellous personality of his art, Degas will say, 'It is strange, for I assure you no art was ever less spontaneous than mine. What I do is the result of reflection and study of the great masters; of inspiration, spontaneity, temperament – temperament is the word – I know nothing. When people talk about temperament it always seems to me like the strong man in the fair, who straddles his legs and asks someone to step up on the palm of his hand.' Again, in reply to an assurance that he of all men now working, whether with pen or pencil, is surest of the future, he will say, 'It is very difficult to be great as the old

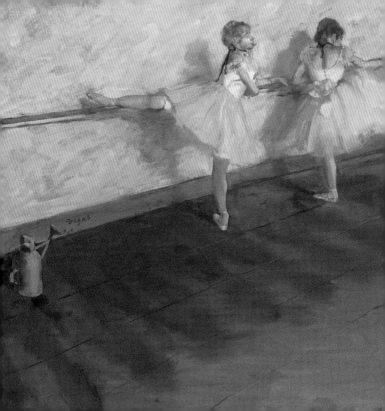

masters were great. In the great ages you were great or you did not exist at all, but in these days everything conspires to support the feeble.'

Artists will understand the almost superhuman genius it requires to take subject-matter that has never received artistic treatment before, and bring it at once within the sacred pale. Baudelaire was the only poet who ever did this; Degas is the only painter. Of all impossible things in this world to treat artistically the ballet-girl seemed the most impossible, but Degas accomplished that feat. He has done so many dancers and so often repeated himself that it is difficult to specify any particular one. But one picture rises up in my mind – perhaps it is the finest of all. It represents two girls practising at the rail; one is straining forward, lifting her leg into tortuous position – her back is turned, and the miraculous drawing of that bent back! The other is seen in profile – the pose is probably less arduous, and she stands, not ungracefully, her left leg thrown behind her, resting upon the rail. The arrangement of the picture is most unacademical; the figures are half-way up the canvas, and the great space of bare floor is balanced by the watering-pot. This picture is probably an early one. It was natural to

Opposite: Dancers Practising at the Barre, 1877

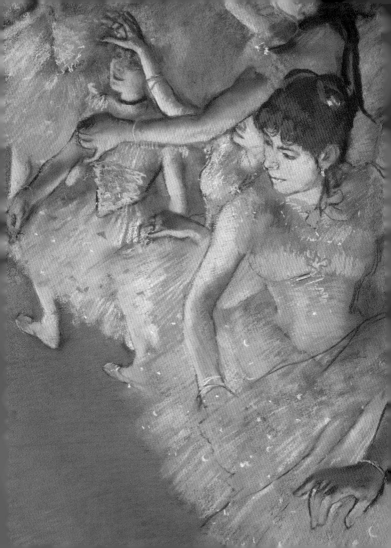

begin with dancers at rest; those wild flights of danc-
ers – the *première danseuse* springing amid the *coryphées*
down to the footlights, her thin arms raised, the vivid
glare of the limelight revealing every characteristic
contour of face and neck – must have been a later
development. The philosophy of this art is in Degas's
own words, 'La danseuse n'est qu'un prétexte pour le
dessin.'* Dancers fly out of the picture, a single leg
crosses the foreground. The *première danseuse* stands
on tiptoe, supported by the *coryphées*, or she rests on
one knee, the light upon her bosom, her arms leaned
back, the curtain all the while falling. As he has done
with the ballet, so he has done with the race-course.
A race-horse walks past a white post which cuts his
head in twain.

The violation of all the principles of composition
is the work of the first fool that chooses to make the
caricature of art his career, but, like Wagner, Degas is
possessed of such intuitive knowledge of the qualities
inherent in the various elements that nature presents
that he is enabled, after having disintegrated, to re-
integrate them, and with surety of ever finding a new
and more elegant synthesis. After the dancers came

* 'The dancer is merely a pretext for the drawing.'

Opposite: Ballet Dancers on the Stage, 1883

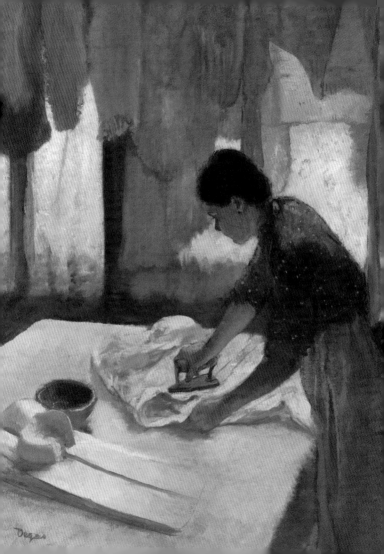

the washerwoman. It is one thing to paint washer-
women amid decorative shadows, as Teniers would
have done, and another thing to draw washerwomen
yawning over the ironing-table in sharp outline upon
a dark background. But perhaps the most astonishing
revolution of all was the introduction of the shop-
window into art. Think of a large plate-glass window,
full of bonnets, a girl leaning forward to gather one!
Think of the monstrous and wholly unbearable thing
any other painter would have contrived from such a
subject; and then imagine a dim, strange picture, the
subject of which is hardly at first clear; a strangely
contrived composition, full of the dim, sweet, sad po-
etry of female work. For are not those bonnets the
signs and symbols of long hours of weariness and
dejection? And the woman that gathers them, iron-
handed fashion has moulded and set her seal upon.
See the fat woman trying on the bonnet before the
pier-glass, the shopwomen around her. How the lives
of those poor women are epitomized and depicted
in a gesture! Years of servility and obeisance to cus-
tomers, all the life of the fashionable woman's shop is
there. Degas says, 'Les artistes sont tellement pressés!

Opposite: Woman Ironing, c. 1876-87

Overleaf: The Milliners, c. 1882-1905

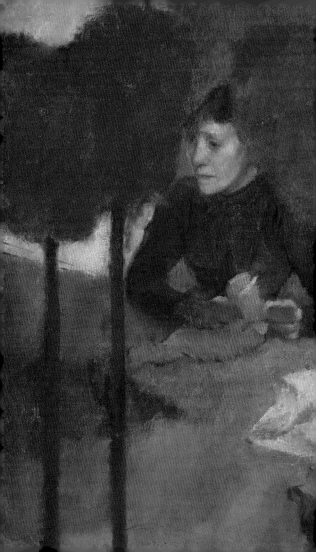

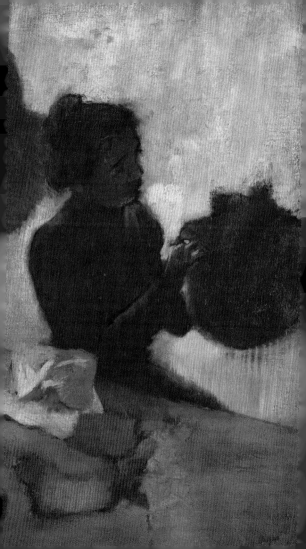

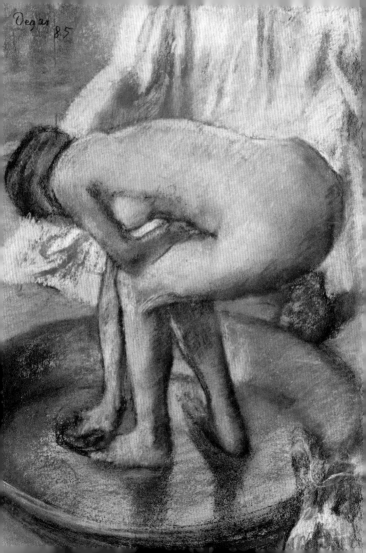

Et que nous faisons bien notre affaire avec les choses qu'ils ont oubliées.' (Artists are always in such a hurry, and we find all that we want in what they have left behind.')

But perhaps the most astonishing of all Degas's innovations are his studies of the nude. The nude has become well-nigh incapable of artistic treatment. Even the more naïve are beginning to see that the well-known nymph exhibiting her beauty by the borders of a stream can be endured no longer. Let the artist strive as he will, he will not escape the conventional; he is running an impossible race. Broad harmonies of colour are hardly to be thought of; the gracious mystery of human emotion is out of all question – he must rely on whatever measure of elegant drawing he can include in his delineation of arms, neck, and thigh; and who in sheer beauty has a new word to say? Since Gainsborough and Ingres, all have failed to infuse new life into the worn-out theme. But cynicism was the great means of eloquence of the Middle Ages; and with cynicism Degas has again rendered the nude an artistic possibility. Three coarse women, middle-aged and deformed by toil, are perhaps the most wonderful. One sponges herself in a tin

Opposite: Woman Bathing in a Shallow Tub, 1885

bath; another passes a rough nightdress over lumpy shoulders, and the touching ugliness of this poor human creature goes straight to the heart. Then follows a long series conceived in the same spirit. A woman who has stepped out of a bath examines her arm. Degas says, 'La bête humaine qui s'occupe d'elle-même; une chatte qui se lèche.'* Yes, it is the portrayal of the animal-life of the human being, the animal conscious of nothing but itself. 'Hitherto,' Degas says, as he shows his visitor three large peasant women plunging into a river, not to bathe, but to wash or cool themselves (one drags a dog in after her), 'the nude has always been represented in poses which presuppose an audience, but these women of mine are honest, simple folk, unconcerned by any other interests than those involved in their physical condition. Here is another; she is washing her feet. It is as if you looked through a keyhole.'

But the reader will probably be glad to hear of the pictures which the most completely represent the talent of the man. Degas might allow the word 'represent' to pass, he certainly would object to the word 'epitomise', for, as we have seen, one of his

* 'The human animal taking care of herself; a cat licking herself.'

Opposite: Woman in the Bath Drying her Arm, 1880 or 1890

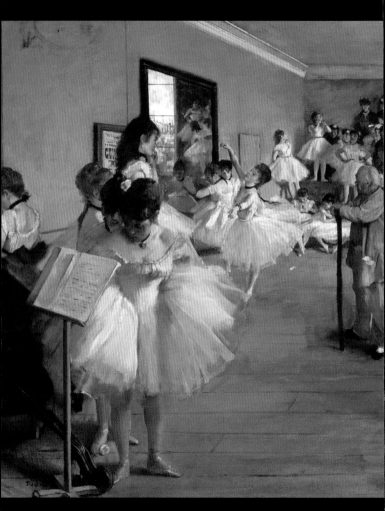

æstheticisms is that the artist should not attempt any concentrated expression of his talent, but should persistently reiterate his thought twenty, fifty, yes, a hundred different views of the same phase of life. Speaking of Zola, who holds an exactly opposite theory, Degas says: 'Il me fait l'effet d'un géant qui travaille le Bottin.'* But no man's work is in exact accord with his theory, and the height and depth of Degas's talent is seen very well in the *Leçon de Danse*, in M. Faure's collection, and perhaps still better in the *Leçon de Danse* in M. Blanche's collection. In the latter picture a spiral staircase ascends through the room, cutting the picture at about two-thirds of its length. In the small space on the left, dancers are seen descending from the dressing-rooms, their legs and only their legs seen between the slender banisters. On the right, dancers advance in line, balancing themselves, their thin arms outstretched, the dancing-master standing high up in the picture by the furthest window. Through the cheap tawdry lace curtains a mean dusty daylight flows, neutralizing the whiteness of the skirts of the opera. The artificial life of the

* 'He makes me think of a giant working through the Paris directory.'

Opposite: Dance Class, 1874 (previously in Faure's collection)

Overleaf: Dance Class, c. 1873 (a variant on the painting discussed by Moore)

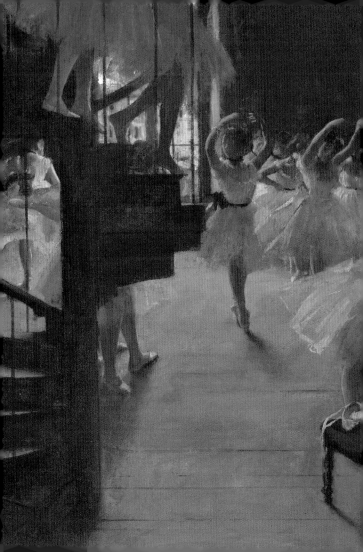

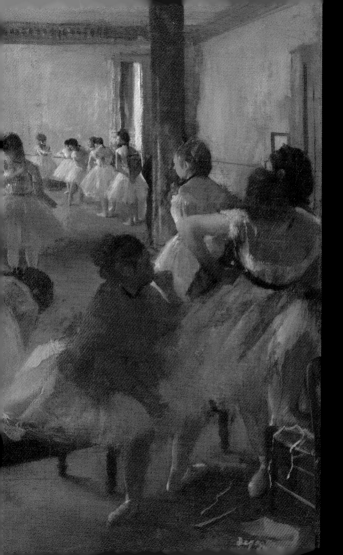

dancing-class on a dull afternoon. On the right, in the foreground, a group of dancers balances the composition. A dancer sits on a straw chair, her feet turned out, her shoulders covered by a green shawl; and by her, a little behind her, stands an old woman settling her daughter's sash.

In this picture there is a certain analogy between Degas and Watteau, the grace and lightness and air of fête remind us of Watteau, the exquisite care displayed in the execution reminds us of the Dutchmen. But if Degas resembles Watteau in his earlier pictures of the dancing-classes at the opera he recalls the manner and the genius of Holbein in his portraits, and nowhere more strikingly than in his portrait of his father listening to Pagano, the celebrated Italian singer and guitarist. The musician sits in the foreground singing out of the picture. Upon the black clothes the yellow instrument is drawn sharply. The square jaws, the prominent nostrils, the large eyes, in a word, all the racial characteristics of the southern singer, are set down with that incisive, that merciless force which is Holbein. The execution is neither light nor free; it is, however, in exact harmony with the intention, and intention and execution are hard, dry, complete. At

Opposite: Degas's Father Listening to Lorenzo Pagano, 1869-72

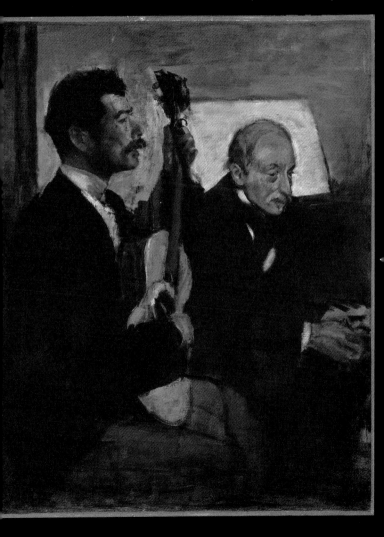

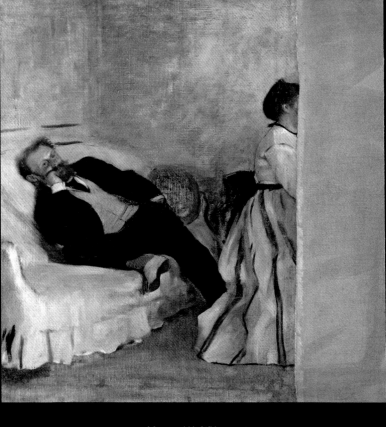

Manet and his Wife, c. 1868-69

the back the old melomaniac sits on the piano-stool, his elbow on his knee, his chin on his hand, the eyelid sinks on the eye, the mouth is slightly open. Is he not drinking the old Italian air even as a flower drinks the dew?

Another great portrait is Degas's portrait of Manet, but so entirely unlike is it to any other man's art that it would be vain to attempt any description of it. It shows Manet thrown on a white sofa in an attitude strangely habitual to him. Those who knew Manet well cannot look without pain upon this picture; it is something more than a likeness, it is as if you saw the man's ghost. Other portraits remind you of certain Spanish painters, the portrait of Mlle Malot for instance; and in his studies of the nude there is a frankness which seems borrowed from the earlier Italians. Degas's art is, as he says himself, based upon a profound knowledge of the great masters. He has understood them as none but a great painter could understand them, and according to the requirements of the subject in hand he has taken from them all something of their technique.

The following anecdote will give an idea of Degas's love of the great masters. In 1840, Degas set up his easel in the Louvre and spent a year copying Poussin's *Rape of the Sabines*. The copy is as fine as the original.

Degas now occupies the most enviable position an artist can attain. He is always the theme of conversation when artists meet, and if the highest honour is to obtain the admiration of your fellow-workers, that honour has been bestowed on Degas as it has been bestowed upon none other. His pictures are bought principally by artists and when not by them by their immediate *entourage*. So it was before with Courbet, Millet, and Corot; and so all artists and connoisseurs believe it will be with Degas. Within the last few years his prices have gone up fifty per cent; ten years hence they will have gone up a hundred per cent, and that is as certain as that the sun will rise tomorrow. That any work of his will be sold for twenty thousand pounds is not probable; the downcast eye full of bashful sentiment so popular with the uneducated does not exist in Degas; but it is certain that young artists of to-day value his work far higher than Millet's. He is, in truth, their god, and his influence is visible in a great deal of the work here and in France that strives to be most modern. But it must be admitted that the influence is a pernicious one. Some have calumniated Degas's art flagrantly and abominably, dragging his genius through every gutter, over every dunghill of low

Opposite: Alice Villette, 1872

commonplace; others have tried to assimilate it honourably and reverentially, but without much success. True genius has no inheritors. Tennyson's parable of the gardener who once owned a unique flower, the like of which did not exist upon earth, until the wind carried the seeds far and wide, does not hold good in the instance of Degas. The winds, it is true, have carried the seeds into other gardens, but none has flourished except in native soil, and the best result the thieves have obtained is a scanty hybrid blossom devoid alike of scent and hue.

WALTER SICKERT

Memories of Degas

November 1917

It is obvious that I owe to the English-speaking world a note on my recollection of Degas while my memory is still vivid. What is desired in these cases is as much first-hand matter as possible, and in the smallest compass. I propose therefore to record briefly, and to expound not at all, or as little as possible.

I was fortunate in having received from my father, who had studied at Couture's, and was more an antique Parisian than a Dane, and from Otto Scholderer (see Manet's *Atelier aux Batignolles*), an excellent preparation for the reception of the teachings of Degas. In 1883, the year in which the portrait of Whistler's mother was exhibited in the Salon, Whistler asked me to take charge of the picture, which I did, crossing by Dieppe. I have a clear recollection of the vision of the little deal case swinging from a crane against the star-lit night and the sleeping houses of the Pollet de Dieppe. Whistler had given me letters to Degas and Manet, and copies of the famous brown-paper catalogue of his etchings to present to them, and I was to say to them that Whistler was 'amazing'. I alighted in Paris at the Hôtel du Quai Voltaire as the guest of Oscar Wilde, whence I paid my first visit to Degas,

Opposite: Miss Lala at the Fernando Circus, 1879

first at his flat in the rue Pigalle – '*mon rocher de Pigalle*'* I have heard him call it – and then, as the reader will see, by appointment at his *atelier* in the rue Fontaine S. Georges.

Degas, whose perpetual characteristic was a rollicking and somewhat bear-like sense of fun, half regarded, and half affected to regard me, erroneously I fear, as the typical and undiluted Englishman, much as Gavarni always addressed his friend Ward as 'l'Anglais'. I prefer to give the account of my first visit through two sufficiently piquant distorting media, to give Oscar Wilde's account of Degas's later story to him. Degas alleged himself to have been disturbed too early in the morning, by a terrific knocking and ringing. He had opened the door himself, his head tied up in a flannel comforter. 'Here at last,' he had said to himself, 'is the Englishman who is going to buy all my pictures.'

'*Monsieur,*' he had said, '*je ne peux pas vous recevoir. J'ai une bronchite qui me mène au diable. Je regrette.*'†

'*Cela ne fait rien,*' the Englishman is here made to say. '*Je n'aime pas la conversation. Je viens voir vos tableaux.*

* 'My rock of Pigalle' [reference to Pisgah, the mountain from which Moses saw the Promised Land]. † 'Sir, I cannot receive you. I have bronchitis that is taking me to the devil. I apologise.'

*Je suis l'élève de Whistler. Je vous présente le catalogue de mon maître.'**

Degas willingly specialised in an imitation of the English method of pronouncing the letter *R*, making of it something like a soft *ch*, as '*maîtche*'. The visitor had then entered, had proceeded silently, and with great deliberation ('*Il n'a pas desserré les dents*'†) to examine all the pictures in the flat, and the wax statuettes under their glass cases, keeping the invalid standing the while, and had ended by saying:

'*Bien. Très bien. Je vous donne rendez-vous demain à votre atelier à dix heures.*'§

The facts are singularly exact. I have seldom known a game of 'German scandal' in which less distortion had taken place.

From that time until my last visit to him, Boulevard Clichy, shortly before the war, I had the privilege of seeing constantly, on terms of affectionate intimacy, this truly great man. '*J'ai beaucoup changé,*'‡ he had said, and, whatever draught of grief was to be mine at his dissolution I drank to the dregs on

* 'No matter, I don't like conversation. I have come to see your pictures. I am Whistler's pupil. I give you my master's catalogue.'
† 'He did not unclench his teeth.' § 'Good. Very good. I will see you at your studio tomorrow at ten.' ‡ 'I have changed a lot.'

that day, as I passed down the rue Victor Massé, and saw the demolished walls of the apartment that had been, since my youth, the lighthouse of my existence. Never again was I to enter the little anteroom where Forain's last published drawing was lovingly laid on its *soigné* pile. A polished mahogany table was affected solely to that use. Never again should I hear old Zoë say, '*Monsieur Degas est en courses: il ne va pas tarder de rentrer. Vous resterez à dîner, n'est-ce-pas?*'* Nor anticipate the feast of instruction and amusement of which I now held the grateful certainty. Fantin-Latour said to me once of Degas: '*C'est un personnage trop enseignant,*'† thus noting a defect which was to me precisely the quality.

He would always bombard me with stories about Englishmen he had known. An English painter of his friends had succeeded in getting a small still-life of a beefsteak skied in the Salon. He would turn, beaming, to everyone he met, with the question, '*Avvy voo voo (vous vu) mon entchecoat (entrecôte)?*'§ When, after 1870, Degas met my compatriot again for the first time, the Briton had greeted him, still beaming,

* 'Monsieur Degas is out shopping, he won't be long. You will be staying to dinner, won't you?' † 'He's too much of a teacher.' § 'Have you seen my steak?'

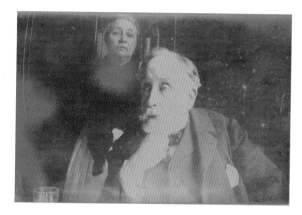

Degas with Zoë, photographic self-portrait

with: — '*Eh bien! J'ai suivi vos destaches (désastres) dans les journaux.*'*

My second meeting with Degas was at Dieppe in the summer of 1885, when we learned with delight that he was staying with the Ludovic Halévys, next door to Dr. Blanche's châlet on the sea-front by the Casino. It was in Jacques Blanche's studio in the Châlet du Bas Fort-Blanc that Degas drew the pastel group that appears as *Ritratti*, in the Italian brochure

*'Well! I've followed your disasters in the papers.'

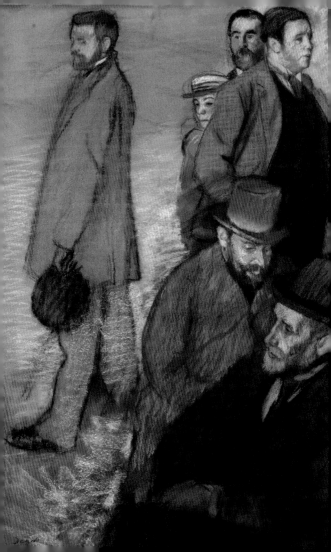

of reproductions of his work, one figure growing on to the next in a series of eclipses, and serving, in its turn, as a *point de repère* for each further accretion. In the order of age the figures were: — Monsieur Cavé, who had been Minister of the Fine Arts under Louis Philippe, and was a friend of Gavarni's, Ludovic Halévy, Gervex, Jacques Blanche, and I and Daniel Halévy. This drawing Degas presented with a profound bow to Madame Blanche when it was finished. Ludovic Halévy pointed out to Degas that the collar of my cover-coat was half turned up, and was proceeding to turn it down. Degas called out: '*Laissez. C'est bien.*' * Halévy shrugged his shoulders and said, '*Degas cherche toujours l'accident.*'† That summer, I remember, Degas was always humming with enthusiasm airs from the *Sigurd* of Reyer.

We went out in a party one day with the vague intention of sketching, into a field behind the Castle, and it was here that Degas said to me a thing of sufficient importance never to be forgotten. 'I always tried,' he said, 'to urge my colleagues to seek for new combinations along the path of draughtsmanship, which I consider a more fruitful field than that

* 'Leave it. It's good.' † 'Degas is always looking for the accident.'
Opposite: Six friends at Dieppe, 1885

of colour. But they wouldn't listen to me, and have gone the other way.' This, not at all as a grievance, but rather as a hint of advice to us, to Broutelles, to Helleu, Ochoa, Jacques Blanche and me. He came to see my sunlight *pochades* in the rue Sygogne and commended the fact that they were '*peints comme une porte*'. '*La nature est lisse*,'* he was fond of saying. He referred me to Boudin. '*Mais tout ça*,' he said, '*a un peu l'air de se passer la nuit.*'† I was expecting Whistler on a visit, and Degas, talking of him, said, '*Le rôle de papillon doit être bien fatiguant, allez! J'aime mieux, moi, être le vieux boeuf, quoi?*'§ I had the immense satisfaction in this, the last summer of my father's life, of introducing him to Degas, when Degas and I happened on my father, who was drawing a pastel of the quai Henri IV from the fishmarket.

When, in the same autumn of 1885, my wife and I visited Degas in Paris, I asked him what he thought of Oscar Wilde. '*Il a l'air de jouer Lord Byron dans un théâtre de banlieue.*'‡

* 'Nature is glossy.' † 'But all that seems to be happening at night.' § 'Playing the part of a butterfly must be tiring, then! I'm happier being the old ox, what?' ‡ 'He has the air of someone playing Lord Byron in a suburban theatre.'

Opposite: At the café-concert, '*The Song of the Dog*', *1875-77*

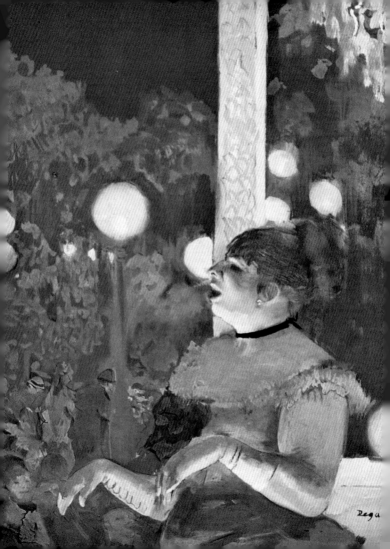

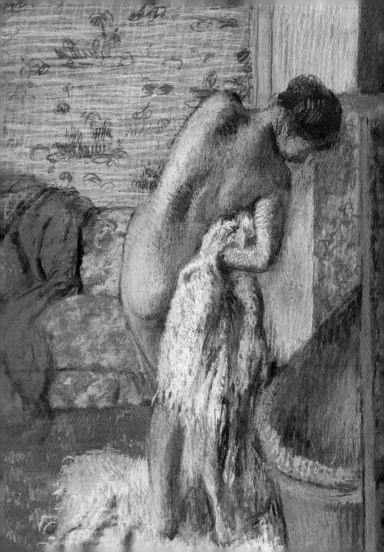

He spoke with enthusiasm of Thérésa and sang the lines

> *Là-bas dans la vallée*
> *Coule claire fontaine (bis)**

from '*J'ai tué mon capitaine*'.

'*Je veux*,' he said, when he was showing us his pastels, '*regarder par le trou de la serrure*.'† This expression, when promptly and duteously retailed by me in London, was received with raised hands by the English press. The somewhat excusable prurience of our Puritans could not conceive of anything being seen through a keyhole but indecencies, and on the strength of this subjective and mathematically erroneous opinion, Degas was promptly classified as a pornographer. '*Qu'est qu'ils feraient à l'Académie Royale si je leur envoyais ça?*' he asked me.

'*Ils vous mettraient surement à la porte!*'

'*Je m'en doutais. Ils n'admettent pas le cynisme dans l'art.*'§

* Down there in the valley / The clear spring is flowing. † 'I want to look through the keyhole.' § 'What would they do at the Academy if I sent them that?' 'They'd surely show you the door.' 'I thought so. They don't admit cynicism in art.'

Opposite: After the Bath, c. 1886

'*Dans la peinture à l'huile il faut procéder comme avec le pastel.*'* He meant by the juxtaposition of pastes considered in their opacity. It must be remembered that I am only recording what he said at a given date, and to a given person. It in no wise follows that, by advising a certain course, he was stating that he had himself refrained from ever taking another. And again, '*On donne l'idée du vrai avec le faux,*'† which I only understood a week ago.

He said that George Moore was very intelligent. He said that the art of painting was so to surround a patch of, say, Venetian red, that it appeared to be a patch of vermilion. He said that painters made too many formal portraits of women, whereas their hundred and one gestures, their *chatteries*, &c., should inspire an infinite variety of design: '*J'ai peut-être trop considéré la femme comme un animal,*'§ he queried some years later.

'*J'ai beaucoup de peine à me mettre au travail le matin,*'‡ and as much in leaving off, was implied. Later, when his eyes were already troubling him – he was very

* 'In oil painting one must proceed as with pastel.' † 'One conveys the idea of the true by means of the false.' § 'I've perhaps looked at women too much as animals.' ‡ 'I have real difficulties to start work in the morning.'

Opposite: Dancers, c. 1899

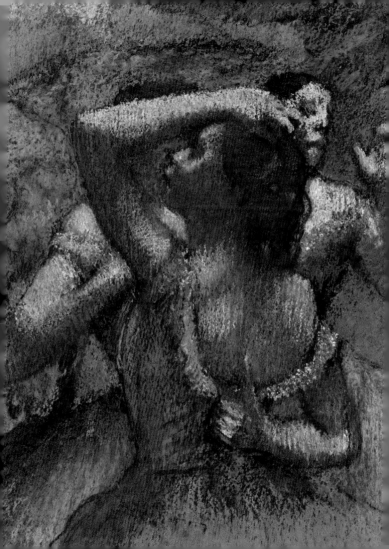

much hindered by a blind spot, the circumventing of which caused him endless fatigue – he said his one joy was to '*grimper à l'atelier*'.* He spoke of this when he was in the seventies, in the gleeful tone which a young man would use in speaking of an escapade. '*Travailler encore un peu avant de mourir.*' '*Une fois que j'ai une ligne, je la tiens. Je ne la lâche plus.*'†

I remember the last time I was in the studio, upstairs in the rue Victor Massé, he showed me a little statuette of a dancer he had on the stocks, and – it was night – he held a candle up, and turned the statuette to show me the succession of shadows cast by its silhouettes on a white sheet.

We were walking one morning down from Montmartre to go to Durand Ruel's. Degas was dressed in a grey flannel shirt, a muffler and a suit that might almost have been ready-made. '*Ce n'est pas,*' I said, stopping as one does on the Continent, '*Sir John Millais qui se présenterait chez Monsieur Agnew fichu comme vous l'êtes.*'§ He pulled up with mock indignation: — '*Monsieur! Quand un Anglais veut écrire une lettre, il se met dans un costume spécial, fait pour écrire une lettre, et après il se rechange.*

* 'To climb up to the studio.' † 'To work a little more before I die.' 'Once I've got a line, I keep hold of it. I never let it go.' § 'Sir John Millais would never show himself at Agnew's in that get up.'

*Être foutu comme quatre sous, et être le grand Condé! Voilà l'affaire! Dites?** He would now and again, in compliment to my nationality, recite the legend that appears to have impressed him most at Brighton: 'Ond *please* (with great emphasis, and an air of pathetic entreaty) hadjust yure dress biffore leaving.' '*Quand un Anglais,*' he once said, '*ne joue pas la comédie pour les autres, il se la joue pour lui-même.*'†

I remember a clean-shaven Forain walking one night into the rue Victor Massé, after a visit to England. We neither of us recognised the keen face, which smacked at once of the bishop and the jockey, till we heard the agreeably grating tone of the well known *traînante* voice:

'*Oui, Monsieur Degas, en Angleterre l'homme bien est toujours rasé.*'

'*Eh bien, Monsieur Forain, en France c'est exactement le contraire. En France il n'y a que les domestiques qui sont rasés.*'§

* 'Sir! When an Englishman wants to write a letter, he dresses himself in a special costume, made for writing letters, and than he changes back again. To look like a beggar and be the Grand Condé! That's the way. Now isn't it?' † 'When an Englishman is not playing a part for others, he plays it for himself.' § 'Yes, Monsieur Degas, in England a gentleman is always clean shaven.' 'Well, Monsieur Forain, in France it is exactly the other way round. In France only servants shave.'

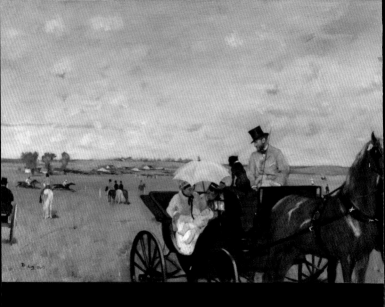

At the Races in the Countryside, 1869

Degas was an *acharné* conservative, and all for the old ways, and the French ways at that. '*Non, Monsieur! Nous ne dressons pas pour dîner!*'* Coffee should be served at table. Do not break up the thread of the party. *Scheuch nicht den holden Traum.*† '*Quand on est dans un pays on prend les mœurs du pays où on se trouve.*'§ His record as *personnage enseignant* must have been when *he* corrected *my* pronunciation of the word 'Byron'. '*Nous disons Lor' Biron,*' somewhat tartly. He was extremely catholic in his appreciation of other people's work. It was for years a matter of amazed awe to us, 'young lions of the Butterfly', that Degas had insisted on qualities in the painting of a waterfall by Frank Miles. The reader may not, I think, conclude from this that he had any tenderness for *The Gardener's Daughter*, or for *I've been roaming*, by the same hand. But there is the fact, in all seriousness.

He took me to the great Exhibition which we entered by the Trocadéro, where countless families were picnicking on the grass. '*C'est l'âge d'or en bronze!*'‡ We studied the British section with some care. He admired a picture of a country wedding by James Charles, and

* 'No, Sir! we don't dress for dinner. † 'Don't dismiss the blissful dream.' § 'When you are in a country you observe its customs.'
‡ 'It's the Golden Age in bronze!'

said, I remember, that the picture would have been better on a somewhat smaller scale. I expressed my admiration for Orchardson's marvellous *Master Baby*. He agreed, but had liked other things of his better, which puzzled, and still puzzles me. But this is neither here nor there. Before Whistler's *Lady Archibald Campbell* he said, 'Elle rentre dans la cave de Watteau.'*

'*Sacré Monet*,' he said to me once, in a burst of playful and admiring jealousy, '*Tout ce qu'il fait est toujours tout de suite d'aplomb, tandis que je me donne tant de mal, et ce n'est pas ça!*'†

Of Sisley he said that the *terrains* always remained somewhat fluttering and wanting in *assise*. Of the school of Vuillard he said he had one reproach to make. Pointing to a drab, and pale, and rather dingy bottle of white wine on the table, he said: — '*Ils feraient de ça un bouquet de pois de senteur.*'§ His wholehearted adoration seemed, among the moderns, to be given to Millet, to Ingres and to the earlier Corot, and Keene, of course, he loved. He hated the 'arty' and all exaggerated manifestations of æsthetic sensibility, real or affected. I said once, I couldn't see that

* 'She's going into Watteau's cellar'. † 'Wretched Monet. Everything he does falls out right straight away, while I go to such trouble and it doesn't work'. § 'They'd make a bouquet of sweet peas out of that.'

So-and-so, who was at the time *le chouchou d'un cénacle,** was a genius. He said, drily, '*Monsieur, ce n'est pas un génie. C'est un peintre.*'† I remember, at a private view of some landscapes with water, where two or three ladies were sitting on separate *poufs* in silent ecstasies of artistic *recueillement*, he said to me, '*Je n'éprouve pas le besoin de perdre connaissance devant un étang.*'§

He was an *enragé* collector. At the rue Victor Massé he had three suites of apartments, one to live in, the one above for his collection, and, at the top of the house, his studio. I have sometimes in the second apartment threaded my way with him, by the light of a candle, through the forest of easels standing so close to each other that we could hardly pass between them, each one groaning under a life-sized portrait by Ingres, or holding early Corots and other things I cannot remember. Among them was one picture, by himself, of a woman playing the piano, and he told me with glee that a musician had recognised the score of music in his picture as '*du Beethoven*'.

Upstairs I watched him with interest one day when he was glazing a painting with a flow of varnish by means of a big flat brush. It represented a lady

* The favourite of a coterie. † 'Sir, he is not a genius. He's a painter.' § 'I don't feel the need to swoon away at the sight of a pond.'

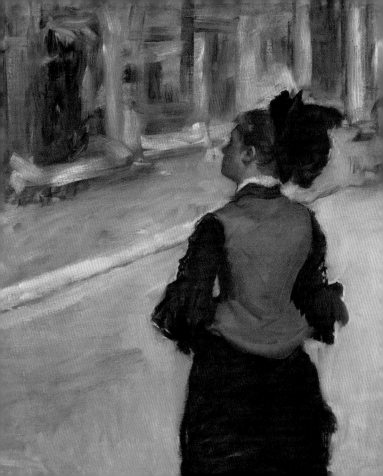

drifting in a picture-gallery. He said that he wanted to give the idea of that bored, and respectfully crushed and impressed absence of all sensation that women experience in front of paintings. As he brought out the background in a few undecided strokes, suggesting frames on the wall, he said with irrepressible merriment, '*Il faut que je donne avec ça un peu l'idée des Noces de Cana.*'* There you have Degas.

He said that Manet had a charming expression. In speaking of a hunchback, for instance, he would say, '*Ça a son chic.*'†

He loved stories about Courbet. Every school boy knows that Courbet had a way of starting a landscape, especially a sunlit waterfall, on a canvas painted black. '*Je fais,*' Courbet would say, '*comme Dieu. Je tire la lumière des ténèbres!*'§ Or, speaking of some worldwide name, Veronese or another, Courbet would say: '*En voilà encore un qu'il faut que je tire au clair!*'‡ And Degas would cover his eyes with his hand to laugh his fill. One day Courbet refused to permit the admission, to an exhibition of his pictures that he had not finished

* 'I've got to make it look a bit like the Wedding at Cana.' † 'He has his own style.' § 'I do as God did, I bring light out of darkness!' ‡ 'And there's another one I've got to explain!'

Opposite: Woman Viewed from Behind (Visit to a Museum), c. 1879-85

Brothel scene, 1877

hanging, of an impatient group of quidnuncs. On second thoughts he asked, '*Qui sont ces messieurs?*'

'*Monsieur Courbet, ce sont les membres d'une société de tir.*'

'*Faites entrer ces Messieurs! Ce sont des gens qui voient juste!*'*

His story of his personal knowledge of Ingres must have been told in French by better pens and better memories than mine. Degas made the acquaintance of Ingres, as a quite young man, by obliging the master in a very effectual manner. Ingres wanted to borrow some of his own canvases for the great Exhibition. An owner, who was afraid of fire in the wooden barracks erected, refused the loan. Degas, who knew the owner, persuaded him that the desire of Ingres must be taken as a command, and Ingres appreciated the intervention. Ingres asked Degas what profession he proposed to adopt, who answered that of a painter. '*C'est grave,*' said Ingres, '*très grave. Enfin, faites toujours des lignes, beaucoup de lignes.*'† Degas was present when Ingres fell with

* 'Who are these gentleman?' 'Monsieur Courbet, they are members of a rifle club.' 'Let them in! Here are people who can see straight.'
† 'This is serious, very serious. Anyway, always make lines, lots of lines.'

Overleaf: Portrait of Mlle. Hortense Valpinçon, c.1871

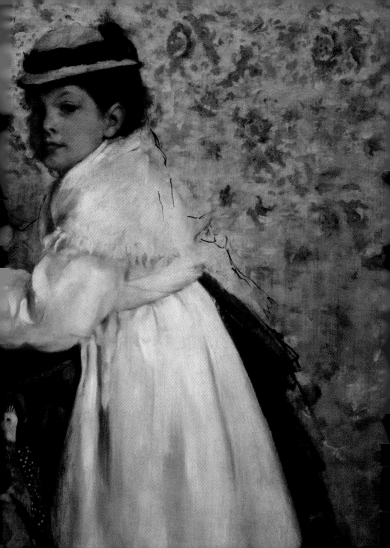

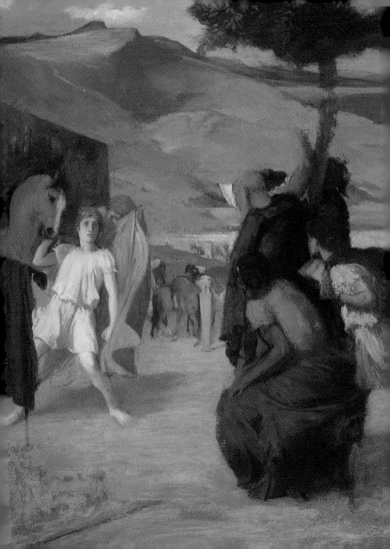

an attack that was to prove fatal, and went himself to fetch Madame Ingres round to the quai Voltaire.

Degas described a scene at the studio of Ingres when the master had a kind of private view of a number of his pictures which were hung on the walls. There were such subjects as *Jupiter*, and, I think, *Homer*, and so on, and also the *Bain turc*, an agglomeration of nudes. A burgess of some importance, passing with the master from the bearded heroes to the nudities, ventured on some gesture approaching a chuckle or a nudge, as who should say 'Sly dog', or words to that effect. '*Monsieur*,' Degas heard Ingres say, as he drew himself up to his full height and bowed stiffly, '*J'ai plusieurs pinceaux.*' '*Voilà un Monsieur avec lequel on ne plaisantait pas,*'* Degas said to me in the Louvre, before the portrait of Ingres.

Talking of Homer, I remember Helleu said to Degas in his old age, '*Monsieur Degas, vous avez l'air de Homère.*' '*Eh bien! Je ne suis pas plus gai pour ça.*'† I remember how Degas took the trouble to write down for me a phrase that particularly delighted him. '*Far*

* 'Sir, I have more than one brush.' 'Here was a gentleman one didn't trade jokes with.' † 'Monsieur Degas, you look like Homer.' 'Ah well! I'm no happier for all that.'

Opposite: Alexander and Bucephalus, 1861-62

tutti mestieri svergognati per compar onoratamente.'* His delighted relish of a phrase like that paints the man as accurately as anything.

Degas had the good-nature and the high spirits that attend a sense of great power exercised in the proper channel, and therefore profoundly satisfied. The sensation that seemed to me to be perpetual with him was comparable to the irrepressible laugh of a boxer who gets in blow after blow exactly as he intended. He earned his living largely. His intellectual vitality, assimilative and creative, was so intense and so absorbing that it seemed he could not be bothered with any of the expensive apparatus of vanity and pleasure which, to less generously endowed natures, seems a necessary compensation. There was his work, and, when his eyes were tired, there was conversation, there were endless rambles through the streets of Paris, and long rides in and on omnibuses. '*Je n'aime pas les fiacres, moi. On ne voit personne. C'est pour ça que j'aime l'omnibus. On peut regarder les gens. On est fait pour se regarder les uns les autres, quoi?*'† And to what good effect he did so we all know.

* 'Do all the lowly tasks in order to live honourably.' † 'I don't like going in a cab. You don't see anyone. That's why I like the omnibus. You can look at people. We're made for looking at each other, what?'

A painter has over a 'public man' the advantage that he is not compelled to spend so much valuable time in 'clearing' his personal character in the law-courts, and in being photographed after each clearance. It is unnecessary to defend a man's memory against those who do not know him. Paris was well aware of Degas, and surrounded him with the profoundest veneration, fear and affection. We read the other day in the English papers that Degas was a 'recluse'. What more natural, then, than to collate him with Matthew Maris? Were they not recluses both? What could be simpler? And are not all recluses somewhat suspect? Has not exclusiveness always seemed a deplorable eccentricity – to the excluded?

English critics have forgotten the derivation of the word artist, which means in Greek 'joiner'. Degas was typically the man who joins together firmly an immense quantity of first-rate material, while Matthew Maris spent half a century washing away, or pulling to pieces, in other words, a microscopic quantity of the flimsiest material imaginable. We may be fighting all over the globe, but we shall remain, in criticism, a right little, tight little island.

Much useless ink has been spilt by the above-touched-upon journalists on the subject of Degas's brusquerie. In all the years I knew him, I have known

of two instances only of severity in his conduct to friends. In the one case a writer had mentioned in print an act of generosity on the part of Degas, which inevitably conveyed a reflection on a third person. Degas considered this a public betrayal of his private affairs, outside the function of a critic, and refused to see the writer again. It seems difficult to see where the hardship in this decision lay, since Degas, by condoning the indiscretion, would have become a party to it. In the other case Degas had sat for his portrait on the understanding that the portrait was not to be exhibited or published during his lifetime. The painter was free to accept or decline the condition. He accepted it, and there was a leakage, a reproduction was published in a magazine. Degas held the painter responsible, and refused to see him any more. If friendship is a form of communication, it is difficult to see how it can be continued after a discovery that both parties are not using the same code. Decision in matters of this kind is rather salutary than otherwise.

Of brusqueries that were *bon enfant* hints, by a man of impeccable politeness, was the famous '*Est-ce que nous vous dérangeons?*' '*Beaucoup!*'* If the greatest painter of the age, who happens not to keep a footman, may

* 'Are we disturbing you?' 'Very much so!'

not, in broad daylight, say that he is occupied, when, in God's name, is it proposed that he should paint?

Degas had a passionate love and respect for the army, and a comprehension of its supreme importance, which must have seemed to the peace-cankered *intellectuels* (*excusez du peu*) of the first years of this century somewhat unreal and unrelated. They know better now.

He was fond of pointing out the fundamental error of conception in Zola's *L'Œuvre*. Zola wrecks the Neo-Innocent painter, who is the hero of the novel, on the rock of a great synthetic effort, where, properly to characterise the movement, he should have come to disaster on dissipation of effort, a kind of running to seed in sketches. Degas was also never tired of quoting the force and concision of Bacon's *homo additus naturæ*,* thus putting the kybosh, by implication, on Zola's lumbering, and too-often-quoted, '*La nature vue à travers un tempérament*',† if that is the phrase.

* [Art is] man added to nature. † '[Naturalism is] nature seen through a temperament.'

List of illustrations

© 2011, 2019 Pallas Athene

Published in the United States of America in 2019 by the J. Paul Getty Museum, Los Angeles
Getty Publications
1200 Getty Center Drive, Suite 500
Los Angeles, California 90049-1682
www.getty.edu/publications

Distributed in the United States and Canada by the University of Chicago Press

Printed in China

ISBN 978-1-60606-609-6

Library of Congress Control Number: 2018954435

First published in the United Kingdom as *Degas: The Painter of Modern Life; Memories of Degas*
by Pallas Athene
Studio 11A, Archway Studios
25–27 Bickerton Road, London N19 5JT

Alexander Fyjis-Walker, *Series Editor*
Anaïs Métais, *Editorial Assistant*

Front cover: Edgar Degas, *Self-Portrait*, 1857–58. Oil on paper, laid down on canvas, 21 x 16.2 cm
(8¼ x 6⅜ in.). Los Angeles, J. Paul Getty Museum, 95.GG.43